BASIC DEVELOP
PRINTING, ENLA
IN BLACK-AND-WHITE

CONTENTS

ISBN 0-87985-182-1

BASIC DEVELOPING, PRINTING, ENLARGING IN BLACK-AND-WHITE

There are many good reasons for knowing something about *making* pictures as well as just *taking* them. You may need to know how to develop film and make prints to earn a merit badge, complete a 4-H project, or make illustrations for a science fair. Maybe you're taking or teaching a photography course in school or at camp.

Perhaps you need to learn something about these techniques to make pictures for your business. Or maybe you picked up this book for the most enjoyable reason of all: because making your own black-and-white enlargements sounds like fun. Whatever your reason for wanting to know about developing, printing, and enlarging, we think you'll find this book a fine introduction for beginners of all ages.

Professional film-processing services (photofinishers) do excellent work and unless you're really bitten by the home-darkroom bug, you might want to let them make most of your pictures. But by doing your own work, you gain more control over the results. You can make prints lighter or darker to suit your needs, enlarge from a small area of a negative, and make prints of any size you want. The cost is modest, and it's a lot of fun.

BASIC STEPS

Before you start a project like this it's a good idea to know where you're going. So here's a brief outline of how we plan to do things. First you'll learn to process your black-and-white film. Of course, if you already have some acceptable black-and-white negatives you can start making prints right away. This is a good idea because you'll also have prints made by a photofinisher to compare with your results.

Making a proof sheet of your negatives comes next, followed by making an enlargement from a negative. You'll also learn different techniques to help improve your enlargements.

Finally, you'll learn how to set up a darkroom and how to do some fun things with your hobby. There's also a chapter with tips on choosing a photographic paper and a list of different chemicals you can use to process and print your films. All these things are explained, step by step, in the pages that follow.

Incidentally, throughout this book we have recommended Kodak products. Similar products are made by other companies.

Now away you go!

PROCESSING FILM

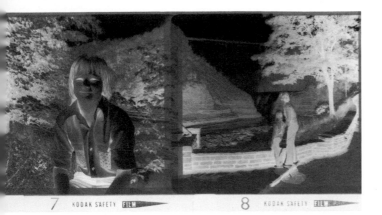

After development, all the light parts of the scene are dark and all the dark parts are light, giving a negative version of the original scene.

When you take a picture, light reflected from the scene strikes the film and makes a latent image. This image is invisible. Now we need something that will convert the latent image into one we can see and use. That's the job of developer.

Film is full of tiny light-sensitive silver halide particles. The particles that have been struck by light turn black when they're put into the developer. After development, all the light parts of the scene are dark and all the dark parts are light, giving a negative version of the original scene.

You'll need a dark room only briefly for processing film. Any room that you can completely darken will do. You can use a closet, basement, your kitchen, or even set up a permanent darkroom (see page 48). You must load the film into the processing tank in complete darkness. All the other steps can be carried out in regular room light. Here's a good test to make sure your room is dark enough. Sit in the room you're going to use as a darkroom for 5 minutes with the lights turned off. After 5 minutes, if you still can't see a sheet of white paper placed against a dark background, the room passes inspection. If there are light leaks, cover them with heavy cloth. Use a rug to cover the crack under the door.

When you take a picture, light reflected from the scene strikes the film and makes a latent image. This image is invisible. It is made visible by processing in special chemicals.

Film is full of tiny light-sensitive silver halide particles. The particles that have been struck by light turn black when they are processed in the first chemical— the developer.

The particles that have not been struck by light will not change in the developer.

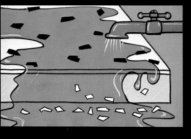

The unexposed silver grains are later made soluble by a processing step called fixing and are washed out of the film.

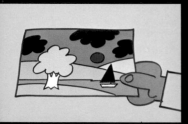

The remaining particles of black metallic silver have formed a visible image, called a negative, in which the original tones are reversed. The light parts of the scene are dark, and the dark parts are light.

Mix all your chemicals with water at the temperature given in the chemical instructions. Rinse the measuring cup between uses so that you don't contaminate one solution with another. Process one roll, and look at your results before doing any more.

The result of this darkroom effort should be a usable negative, if you exposed the film correctly. You'll soon learn the appearance of a properly exposed and properly developed negative. It will have considerable detail, even in the lightest and darkest portions. It's not all dark or all light. The illustrations of negatives on pages 14, 15, 36, and 37 show what to look for.

Try to evaluate your own negatives. A very common fault is over-development, which produces dark, dense negatives.

The scientific way to avoid over- and underdevelopment is to use the time-temperature approach. Develop for the recommended *time* at the recommended *temperature,* and you can hardly help but get good negatives. These recommendations are listed below and are found in the instruction sheets that come with most Kodak black-and-white films.

The traditional temperature in black-and-white darkroom work is 68°F (20°C). That's the solution temperature for which the recommended times are given to process paper or film. Maybe you can't adjust your solutions to that temperature for some reason. When your solutions are warmer than 68°F (20°C), you have to develop for less than the usual time, because chemical reactions are faster at higher temperatures. By the same token, solutions colder than 68°F (20°C) take a longer-than-normal developing time. Exactly how long? Check the table below.

KODAK Packaged Developer for KODAK Films	Developing Times (in Minutes)—Small Tank*				
	65°F (18.5°C)	68°F (20°C)	70°F (21°C)	72°F (22°C)	75°F (24°C)
PANATOMIC-X					
D-76	6	**5**	4½	4¼	3¾
D-76 (1:1)	8	**7**	6½	6	5
MICRODOL-X	8	**7**	6½	6	5
MICRODOL-X (1:3)†	13	**12**	11	10	8½
VERICHROME Pan					
D-76	8	**7**	5½	5	4½
D-76 (1:1)	11	**9**	8	7	6
MICRODOL-X	10	**9**	8	7	6
MICRODOL-X (1:3)†	15	**14**	13	12	11
PLUS-X Pan					
D-76	6½	**5½**	5	4½	3¾
D-76 (1:1)	8	**7**	6½	6	5
MICRODOL-X	8	**7**	6½	6	5½
MICRODOL-X (1:3)†	—	**—**	11	10	9½
TRI-X Pan					
D-76	9	**8**	7½	6½	5½
D-76 (1:1)	11	**10**	9½	9	8
MICRODOL-X	11	**10**	9½	9	8
MICRODOL-X (1:3)†	—	**—**	15	14	13
DK-50 (1:1)	7	**6**	5½	5	4½

*Agitation at 30-second intervals throughout development. Primary recommendations are in bold type.
†For greatest sharpness. (See developer instructions.)

THINGS YOU'LL NEED

1. A processing tank designed to take your film size. If you intend to process 110 film, be sure to use a small tank.

2. A darkroom thermometer to measure temperatures of solutions.

5. 3 large jars.

6. A darkroom timer or a clock with a sweep-second hand.

3. A 32-ounce (946 millilitre) dark-room graduate or kitchen measuring cup.

4. Some film clips or spring-type clothespins.

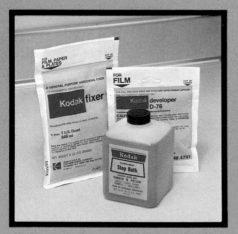

7. Chemicals: KODAK Developer D-76, KODAK Indicator Stop Bath, and KODAK Fixer or KODAFIX Solution.

8. A stirring rod to mix the chemicals.

PROCESSING
YOUR FILM

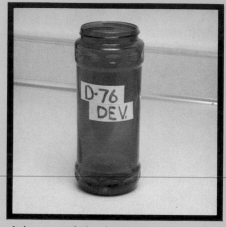

1. In one of the jars, mix the developer according to the package instructions. Label the jar **D-76** DEVELOPER (DEV.).

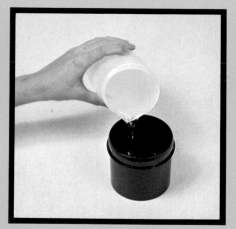

4. Stabilize the developer at 68°F (20°C).[1] Pour the required amount into the developing tank.

[1]Do this by placing your graduate (filled with the required amount of solution) into a tray of warm or cool water until the temperature has stabilized. The water level in the tray should be at least equal to the level of solution in the graduate.

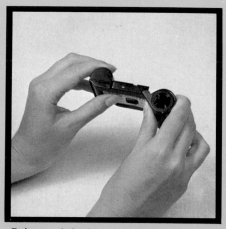

5. In *total darkness* remove your film from the cartridge. With 126- and 110-size films, break open the cartridge by bending the cylindrical chambers toward the label.[2]

[2]If you're using roll film, rip off the EXPOSED sticker, and then separate the film and paper backing. Use a bottle cap remover to open 35 mm magazines.

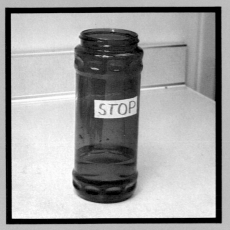

2. In the second jar, mix the stop bath according to the package instructions. Label the jar STOP BATH or STOP.

3. In the third jar, mix the fixer according to the package instructions. Label this jar FIXER.

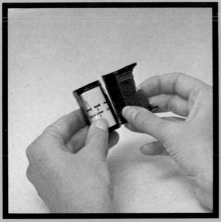

6. To remove the film from 126 cartridges, separate the plastic sections surrounding the spool. If you're using 110 film, pull the paper backing out of the broken cartridge in a direction that rubs the paper against the cartridge. The film will come out along with the backing. Handle the film by the edges only.

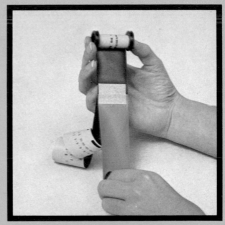

7. The film in 126 cartridges is attached to the paper backing with a strip of tape. Detach the film and discard the paper and tape. Handle the film by the edges only.

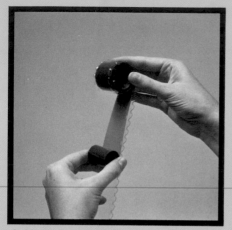

8. Handling the film by the edges, roll it into the apron or reel according to the tank instructions. Put the reel or apron into the tank, secure the lid, and start timing. You may now turn on the room lights.

9. Tap the tank against your working surface to remove any air bubbles. After 30 seconds, agitate the tank by inverting it, rotating it in a circular motion, or rotating the reels. Do this for about 5 seconds at 30-second intervals. At the end of the recommended developing time, pour the solution back into the developer jar.[3] When pouring, tip the tank only slightly at the start.

12. Remove the tank cover, place the tank under a moderate stream of 65 to 75°F (18 to 24°C) water, and let the film wash for about a half hour.

To shorten washing time, rinse the film in KODAK Hypo Clearing Agent (see page 67). First wash the film for 30 seconds. Next submerge it in a Hypo Clearing Agent solution for 1 to 2 minutes, with moderate agitation. Then you need only wash for 5 minutes.

[3]For information about the life of your developer, read the instruction sheet.

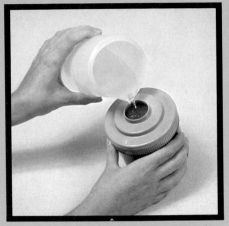 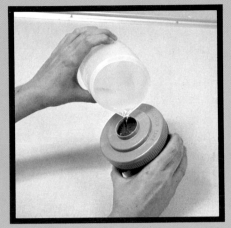

10. With the tank tilted a bit, pour the stop-bath solution (stabilized at 65 to 75°F—18 to 24°C) through the opening in the top. *Do not open the tank.* Agitate gently for about 30 seconds, then pour the liquid back into its original jar.

Note: It's a good idea to rinse your graduate after each of the processing steps.

11. Add the fixer solution (stabilized at 65 to 75°F—18 to 24°C) and agitate as before. At the end of the fixing time (2 to 4 minutes with KODAFIX Solution—5 to 10 minutes with KODAK Fixer), pour the solution into its jar.

13. Hang up the film with a film clip or clothespin at each end. Dampen a viscose sponge, wring it out, and then gently run it along both sides of the film to remove large droplets of water. (To eliminate the necessity of wiping the film, minimize water marks and drying streaks, and shorten drying time, rinse the film with diluted KODAK PHOTO-FLO Solution. Follow the instructions on the bottle.) Let the film dry. Don't forget to rinse out all parts of your film tank.

THINGS THAT CAN GO WRONG

Streaky Negatives—Due to uneven development. Probably not all of the film was in contact with the developer throughout development time or there simply wasn't enough solution.

Rows of Regularly Spaced Marks—If they occur inside the picture area of the negative, it's because the film wasn't properly seated in the apron or because you used the wrong apron.

Black Streaks—A sign that light reached the film while you were loading or unloading your camera. If all the streaks are on the same side, it might be because the top of your developing tank was loosened during processing.

Overall Grayness—Often caused by light sneaking into your darkroom during the time you were loading your developing tank.

Thin, Very Transparent Negatives—If there are no really dark black areas in the entire negative, it usually means that your developer was too cold, the developing time was too short, or the negative was underexposed.

Dense, Heavy Negatives—This indicates that the developer was too warm, the film was developed too long, or the negative was overexposed.

PROOF SHEETS

Proof sheets consist of many prints made from a strip or strips of your negatives. These prints are the same size as your negatives. Proof sheets help you choose the best negatives for enlarging and make a good record to file with your negatives. Remember that your negatives won't all have the same density, so some of the individual prints on your proof sheet will be darker than others.

Proof sheets are made by placing negatives into contact with photographic paper. Light shining through the negative forms an image on the paper. When you immerse this paper into three successive solutions—developer, stop bath, and fixer—you end up with a proof sheet.

Since photographic paper is sensitive to light, you must handle it in a dark place. Paper isn't as sensitive to light as film however, and you will be processing it under safelight illumination. For more information on darkrooms and safelight placement, see page 48.

THINGS YOU'LL NEED

1. A printing frame and a 7-watt light bulb or an enlarger and a piece of glass.

You can make a printing frame by using a piece of window glass and a piece of composition board. Both pieces should be the same size. Put one piece on top of the other and use wide adhesive tape to make a hinge connecting the two pieces. (It's a good idea to tape the remaining edges of the glass so that you won't cut yourself.)

2. Four trays such as KODAK DURAFLEX Trays, 8 x 10 inches.

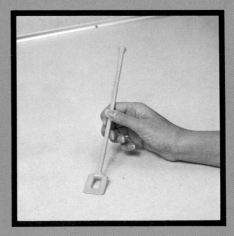

3. A stirring rod to mix the chemicals.

4. A 32 oz (946 mL) darkroom graduate or kitchen measuring cup and 3 large jars.

7. Photographic paper such as KODAK POLYCONTRAST Rapid II RC Paper, 8 x 10 inches.

8. A darkroom thermometer to measure temperatures of solutions.

5. A safelight, such as a KODAK Darkroom Lamp with a KODAK Safelight Filter OC (light amber).

6. Chemicals: KODAK DEKTOL Developer, KODAK Indicator Stop Bath, and KODAK Fixer or KODAFIX Solution.

9. A darkroom timer or a clock with a sweep-second hand.

10. A sponge or a squeegee such as the KODAK Rubber Squeegee.

MAKING A PROOF SHEET

If you've processed your own film, you have already prepared the stop bath and fixer. Mix the developer according to the instructions, pour it into a jar labeled **DEKTOL** DEVELOPER, and start with step 2.

1. In your 3 large jars, mix the developer, stop bath, and fixer solutions according to the package instructions. Label the jars **DEKTOL** DEVELOPER, STOP BATH, and FIXER

4. Stabilize the fixer at 65 to 75°F (18 to 24°C) and pour about ½ inch into a tray labeled FIXER.

Note: It's a good idea to rinse you graduate after steps 2, 3, and 4.

2. Stabilize the developer at 68°F (20°C) by pouring about 32 oz (946 mL) into your graduate and placing it into a tray of cool or warm water. Next, pour it into a tray labeled DEVELOPER to a depth of about ½ inch.

3. Stabilize the stop bath at 65 to 75°F (18 to 24°C) and pour about ½ inch into a tray labeled STOP BATH or STOP.

5. Arrange your trays in front of you so that, from left to right, you have developer, stop bath, and fixer. Then rinse your hands well and dry them thoroughly. **Turn off all lights except the safelight.** The safelight should be placed at least 4 feet from your working area.

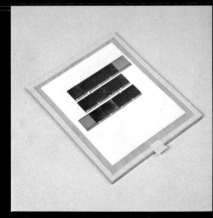

6. Open the package of paper, remove one sheet, and close the package again so that light can't get in. Place your negatives so that their dull side faces the shiny side of the paper. The negatives should be near the light source. Cover with the glass.

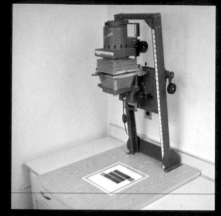

7. If you're using a printing frame and a 7-watt bulb to make your proof sheet, hang the bare bulb 2 feet above the frame and turn it on for about 10 seconds. You may have to experiment a bit (see step 12) to get the correct exposure time for your negatives.

8. If you're using an enlarger, place the empty negative carrier in the enlarger, and set the lens at $f/11$. Adjust the enlarger so that the light covers an area just a bit larger than your paper. Expose for about 8 seconds. Again, you may have to experiment to get the correct exposure time.

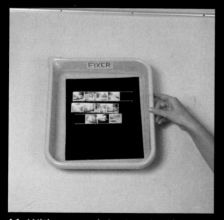

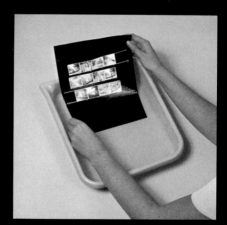

11. With your right hand, withdraw the paper from the stop bath and slip it into the fixer. Agitate frequently for 2 minutes, and keep it separated from any other prints in the tray. After the print has been in the fixer for 25-30 seconds, you can turn on the room lights.

12. Examine your proof sheet and if most of the pictures seem too light, try again with double the exposure time you used at first. If most of the pictures seem too dark, use half the exposure time. It's a good idea to keep notes on your exposure times and the results. You'll soon be able to come up with a good average exposure time to use.

9. Remove the paper from your printing device with your left hand (don't get the right one wet with developer) and slide the paper, shiny side up, into the developer (left-hand tray). Rock the tray gently for 1 minute by tipping up first one end, then the other.

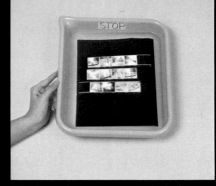

10. Take the paper out of the developer with your left hand, and after letting it drain for a second or two, slide it into the stop-bath solution (center tray). Agitate the tray for 5 seconds in the same manner you did in step 9.

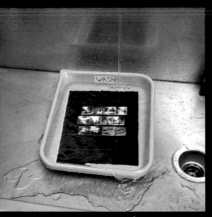

13. Using your fourth tray, wash the print for only 4 minutes at 65 to 75°F (18 to 24°C). Use running water, and agitate the print frequently while it is washing.

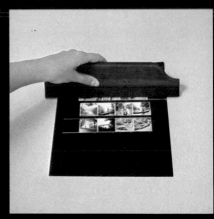

14. Sponge or squeegee the surface water from both sides of the print, and place it onto a flat surface to dry at room temperature.

ENLARGING

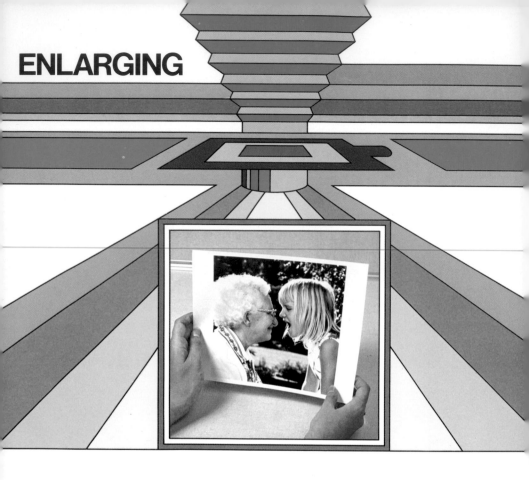

You'll find a lot of satisfaction in making enlargements from your favorite black-and-white negatives. This chapter tells you how to go about it.

First of all, you'll need an enlarger. There are many kinds of enlargers, and your photo dealer will be glad to help you select one to suit your needs. Before continuing, be sure to become completely familiar with your enlarger. Read the instruction manual!

Before the negative goes into the enlarger, it has to be placed into a negative carrier. This is a glass or metal part that holds the negative in the enlarger. Light is passed through the negative and then directed by the enlarger lens onto an easel, which is a board that holds your paper.

Let's start out with one of the negatives you used for making your proof sheet. The project this time will be to make an enlargement of this negative. You'll do these things in the same darkroom you used for contact printing, using the same safelight.

THINGS YOU'LL NEED

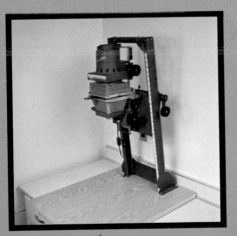

1. An enlarger.[4]

2. The same safelight you used for contact printing.

[4]If you plan to enlarge 110-size film, be sure your enlarger is equipped with a carrier designed for this size film. To enlarge 110-size film successfully, you need an enlarger lens with approximately a 25 mm focal length.

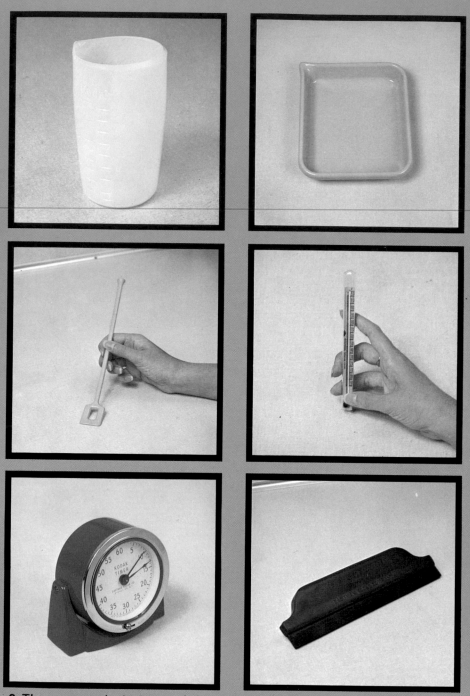

3. The same graduate, trays, stirring rod, thermometer, timer, and sponge or squeegee you used when making a proof sheet.

4. The same KODAK POLYCONTRAST Rapid II RC Paper that you used when making a proof sheet.

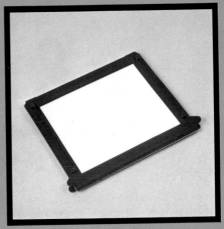

5. An easel to hold the paper.

6. The same chemicals you used when making a proof sheet. (For other chemicals, see page 66.)

7. A camel's-hair brush.

MAKING AN ENLARGEMENT

If you've already made a proof sheet, you've had a good introduction to enlarging. The processing steps are nearly the same. And you'll be using the same chemicals used for the proof sheet.

Enlarging is fun and rewarding, so let's get started!

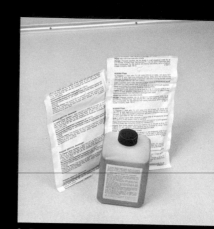

1. Prepare your chemicals according to the instructions packaged with them.

4. Holding the negative gently by its edges, dust it on both sides with the camel's-hair brush. Select the correct negative carrier (dust it also if it's glass), and place your negative into it so that its emulsion side (that's the dull one) is down.

2. Put about ½ inch each of developer, stop bath, and fixer into 3 trays, just as you did when making a proof sheet.

3. The wash tray goes to the right of the fixer. Or you can place it in a sink, if one is convenient.

5. Slide a sheet of smooth, white, typing paper beneath the guides of the enlarger easel for a focusing aid; turn the safelight on and the room lights off. Wait a minute for your eyes to adjust.

6. Set the enlarger lens at its widest opening (the smallest number on the lens mount), turn the enlarger on, and by adjusting its height, arrange your picture so that the desired negative image appears within the easel guides.

7. By adjusting the enlarger lens, bring your picture into the sharpest possible focus. Once this is done, change the lens setting to *f*/11, and turn the enlarger off. Take a sheet of KODAK POLYCONTRAST Rapid II RC Paper, and place it onto the easel, emulsion (shiny) side up.

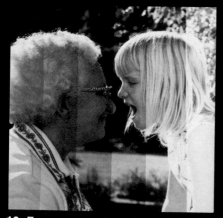 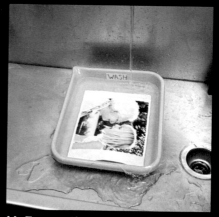

10. From your print, choose the exposure time giving the most pleasing result. Turn out the room lights, and put a piece of photographic paper, shiny side up, into the easel.

11. Expose the paper and process it as you did the test print but with a 2-minute fixing time. Lights can go on after 25-30 seconds. Wash the enlargement for only 4 minutes at 65 to 75°F (18 to 24°C). Use running water and agitate the print frequently while it is washing.

8. Cover all but a sixth of this sheet with a piece of cardboard, and turn on the enlarger. Every 5 seconds, expose an additional sixth of the paper. At the end of 30 seconds, turn the enlarger off.

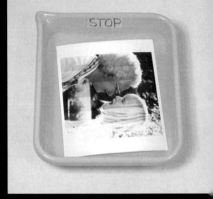

9. Process this test sheet for 1 minute in the developer and 5 seconds in the stop bath; then slide it into the fixer for 25-30 seconds, and turn the room lights on.

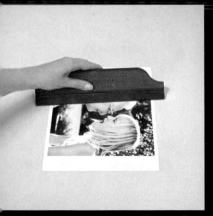

12. Sponge or squeegee the surface water from both sides of the print, and place it onto a flat surface to dry at room temperature.

EVALUATING THE PRINT

After the print has been in the fixer 25-30 seconds, you can turn on the room lights and examine your print. If you have a print made by a photofinisher, compare the two. Is yours too light? Too dark? If your print looks too light, make another with double the exposure time. If the print is too dark, cut the exposure time by half.

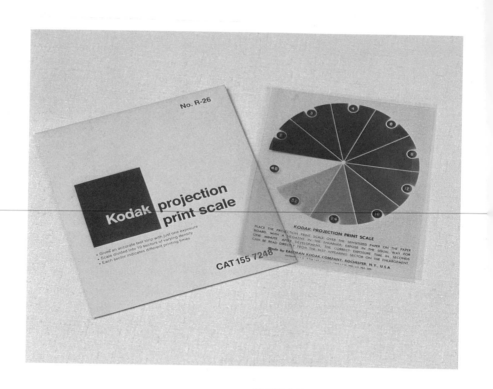

KODAK PROJECTION PRINT SCALE

Now you've made an enlargement. Remember the method you used to find the right exposure—making a test print of different exposure times? Well there's an easier way to do it. The KODAK Projection Print Scale is a piece of film divided like a pie, with a number in each of its 10 slices. To use it, you focus the negative, turn off the enlarger, and place a piece of enlarging paper onto the easel with the print scale so that it reads correctly on top of it. Turn on the enlarger for exactly 1 minute with the lens set at $f/11$. Then process the paper. Pick the section of the pie that looks best. The number in that section will be the exposure time in seconds.

KODAK PROJECTION PRINT SCALE

PLACE THE PROJECTION PRINT SCALE OVER THE SENSITIZED PAPER ON THE PAPER BOARD. WITH A NEGATIVE IN THE ENLARGER, EXPOSE IN THE USUAL WAY FOR ONE MINUTE. AFTER DEVELOPMENT, THE CORRECT EXPOSURE TIME IN SECONDS CAN BE READ DIRECTLY FROM THE BEST APPEARING SECTOR ON THE ENLARGEMENT.

Made by EASTMAN KODAK COMPANY, ROCHESTER, N.Y., U.S.A.

PATENTS: U.S.A., 2,226,167; CANADA, 1942 • T.M. REG. U.S. PAT. OFF.

This picture was printed with the projection print scale on it. Pick the section of the scale that looks best. The number in that section will be the exposure time in seconds. In this case, the exposure would be 8 or 12 seconds, depending on your preference.

You can improve many pictures by printing only the best part of the scene. The picture on the right has a lot more impact than the one above. A lot of the background was cropped out to make a close-up of the two girls.

ENLARGING PARTS OF NEGATIVES

Although you enlarged the whole negative when making your first enlargement, you may want to enlarge only a part of the negative. You can improve many pictures by printing only the best part of the scene, eliminating cluttered backgrounds or unimportant areas. This is called cropping.

Suppose, for example, that your negative is a full-length picture of a person. If you like, you can enlarge just the small area of the negative containing the image of the person's head. When enlarging only part of a negative, be sure to use more exposure time than you did when enlarging the whole negative.

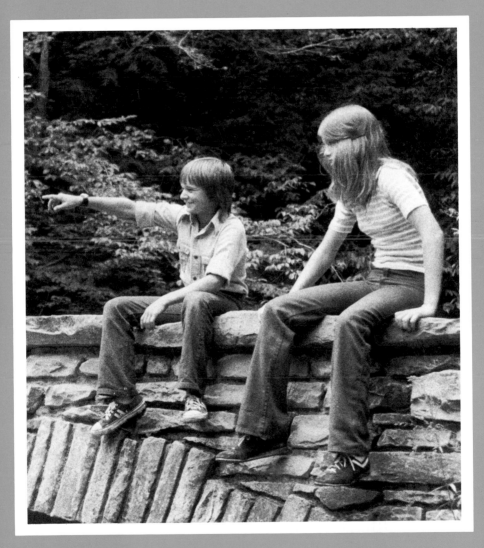

Normal negative.

A print made with a KODAK POLYCONTRAST Acetate Filter PC1 is flat.

NOW TRY THIS

KODAK POLYCONTRAST Rapid II RC Paper is a selective-contrast paper. When exposed with the proper KODAK POLYCONTRAST Acetate Filter or equivalent, this paper can have seven different degrees of contrast.[5]

[5] The KODAK POLYCONTRAST Filter Kit (Model A) contains seven filters that enable you to vary the contrast range of KODAK POLYCONTRAST Papers in half-step intervals from No. 1 to No. 4 contrasts.

For more information on contrast grades, see page 61.

Without a filter, KODAK POLYCONTRAST Rapid II RC Paper is like a grade 2 paper. For normal negatives this will be sufficient. Flat, low-contrast negatives need a hard or contrasty paper like grade 3 or 4 to make good prints. Contrasty negatives, on the other hand, should be printed with a soft grade, like grade 1. You might try printing some of your own flat or contrasty negatives with the correct filter. Different types of negatives are illustrated here to help you see what they look like.

A print made without a filter or with a PC2 Filter looks good.

A print made with a PC4 Filter is contrasty.

Contrasty negative.

PC1 Filter.

Low-contrast negative.

PC4 Filter.

COMPOSITION

Composition means the arrangement of the lines and areas that make up your picture. While entire books have been written on composition, there are a few basic pointers that will help you compose the most pleasing and interesting enlargement. For example, it's usually best to have the center of interest other than in the middle of the picture or too near the margins. Also, try to keep the horizon line in scenic shots above or below the midpoint of the picture, rather than dividing the picture right in the middle.

Your picture should tell its story as simply and clearly as possible. This means you should try to eliminate areas and details that are unnecessary or distracting. Often you can do this simply by shifting the enlarger easel. Or perhaps you can enlarge the picture more, to eliminate distracting areas near the edges.

If your picture contains a light area that draws attention away from the main subject or an area that would print too dark, you may be able to correct this by printing-in or dodging.

CONTROL TECHNIQUES

Up until now we've been concerned primarily with making straight enlargements—enlargements made without the use of any special control techniques. However, using control techniques, along with print-finishing techniques (see page 44), often makes the difference between a good print and an excellent one. Of course, not all negatives require special printing treatment. But since control techniques are quite useful, this section will cover some of the most important controls, such as dodging, printing-in, and others. These are the tools you can use to produce high-quality enlargements.

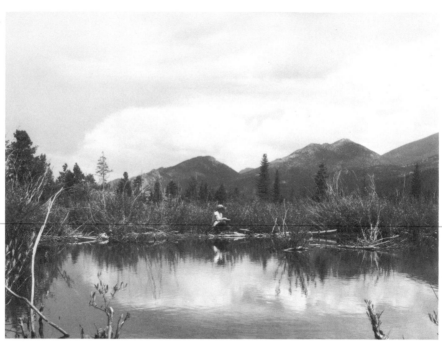

There are many situations where printing-in comes in handy. In the picture above, the clouds are rather weak and washed-out. Printing-in darkens them and makes them more dramatic as in the picture on the right.

After you've given the print a normal exposure, hold a piece of cardboard under the enlarger lens about midway between the lens and the print. Turn on the enlarger, and move the cardboard so that only the area of the print that is too light receives additional exposure.

PRINTING-IN AND DODGING

In many instances, the brightness range of a subject is far beyond the range of tones that can be reproduced in a print. However, you can partially compensate for this in two ways: (1) You can give additional exposure to the highlight areas that would otherwise print too light. This is called printing-in or burning-in. (2) You can hold light back from areas that would otherwise print too dark. This is called dodging.

You can easily make your own printing-in and dodging tools from wire, black tape, and dark paper or cardboard. When you use these tools, always keep them moving so that you won't be able to see a sharp line on the finished print, indicating where you printed-in or dodged.

Printing-In

There are many situations where printing-in comes in handy. For example, let's assume you've taken a flash picture of a group of people. When you make a straight print from the negative, the people in the foreground will probably be much lighter than those who were farther from the camera. You can darken the people in the foreground by printing-in. After you've given the print its normal exposure, hold a piece of cardboard under the enlarger lens about midway between the lens and the print. Turn on the enlarger and move the cardboard so that only the area of the print that is too light receives additional exposure. If the area you want to darken is small or near the center of the print, it's easier to confine the additional exposure to that area if you do the printing-in with a piece of cardboard in which you've cut a hole. Remember to keep the cardboard in continuous motion so that the doctoring won't be apparent on the finished print.

A technically good print of a landscape which reproduces all the tones in the original scene may be weakened pictorially by light-toned areas which compete for attention with the center of interest. These light areas could be bright stones in the foreground, bright reflections, a white house, a light sky, or some other distracting element. You can darken such areas by printing-in.

If the line between the satisfactory area and the area you want to darken is rather intricate, you can make a printing-in tool from a test print of the same size. Just cut the area you want to darken out of the test print. After you've given your final print its normal exposure, print-in the area that is too light by holding the cutout print very close to the paper you are exposing. Move the cutout print only very slightly during the exposure.

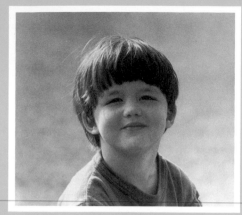

This is the original picture. The boy's face is filled with shadow.

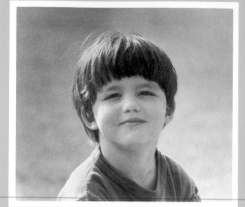

Dodging helps eliminate some of the shadows and make the boy's face lighter.

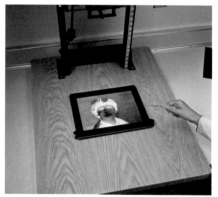

While you expose the print, hold the cardboard by the wire and move it over the area of the projected image that is too dark.

Dodging

In dodging, you hold back light from the projected image during the basic exposure time so that the photographic paper receives less-than-normal exposure in areas that were too dark in your straight print. The tools used in dodging are also very simple to make. You can cut any shape you need from a piece of dark cardboard or paper, and tape it to a piece of wire. Then while you expose the print, hold the cardboard by the wire and move the cardboard over the area of the projected image which is too dark. In dodging, besides keeping the cardboard in motion, make sure you move the wire from side to side too. Otherwise you can get a light line on your print, caused by the shadow of the wire.

The background in this picture is quite distracting, especially the arm in the lower left corner.

Vignetting gets rid of the unpleasant background and makes a very pleasing portrait.

VIGNETTING

Vignetting is a printing technique used to eliminate distracting or unwanted backgrounds. This technique is used primarily in enlargements of people. Vignetting is most popular for printing high-key portraits—portraits of a subject made up mostly of light gray tones.

You can easily vignette a print by projecting the image from the negative through a hole in an opaque cardboard. Cut the hole in the cardboard the same shape as the area you want to print. The hole should be the size that will give you the effect you want when you hold the cardboard about halfway between the enlarger lens and the paper. Feather or rough-cut the edges of the hole so that the image fades gradually into the white paper. In vignetting, keep the vignetter in continuous motion during the print exposure.

You can use the vignetting technique to print portraits from more than one negative on a single sheet of enlarging paper. Assume you want to print from three negatives. Decide where you want each image to appear on the final print, and draw circles on a sheet of white paper on the enlarger easel to indicate the location of each image. Put the first negative in the enlarger and adjust it so that the image you want fills its circle. Remove the white sheet of paper and make your exposure test for the first negative. It isn't necessary to use the vignetting technique for your exposure test. Using the vignetting technique, make the first exposure on the enlarging paper that will be your final print. (It's a good idea to put a small "x" in one corner on the back of the enlarging paper to help keep it properly oriented.) After you make the exposure, put the sheet of enlarging paper back into its lighttight storage place. Put the paper with the circles on it back into the easel and adjust the enlarger for the second picture. Follow the same procedure as you did for the first negative. After you've printed the second negative, follow this same procedure for the third negative. Then process the print.

Most photographers use a material such as KODAK Dry Mounting Tissue, Type 2, for mounting their prints.

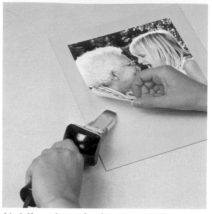

Holding the print in place, lift one corner and tack the mounting tissue to the mount. Do this on all *corners.*

PRINT-FINISHING TECHNIQUES

After you've processed your enlargement, there are a number of finishing techniques you can use to add the final touch that can set your enlargement apart from others. This section describes some of those techniques.

MOUNTING

A mount dissociates a picture from its surroundings and therefore emphasizes the picture. Usually a special mounting board is used for this purpose. A well-chosen mount directs attention to the picture, not to itself. Most photographers use a material such as KODAK Dry Mounting Tissue, Type 2, for mounting their prints. Here's how to mount a print:

1. Tack the heat-sensitive tissue to the center of the back of the print, using a tacking iron or a household iron. (Set the household iron at the lowest setting in the synthetic fabrics range and adjust if necessary.)

2. Trim the print and position it on the mounting board. Holding the print in place, lift one corner of the print and tack the mounting tissue to the mount. Do this on *all* corners.

3. If you plan to use a dry-mounting press, be sure to protect the print with a double thickness of heavy kraft wrapping paper. Before you put your print into the press, make sure that the kraft paper is completely dry. Close the press on the kraft paper for about 1 minute. This will keep the paper from sticking to the surface of your print. Place your covered print in the press and close the press for at least 30 seconds. The temperature of the press should be between 180 and 210°F (82 and 99°C).

4. Remove the mounted print from the press, place the print face down on a clean, smooth surface, and keep flat until cool. A heavy book or other flat weight is useful for this purpose.

5. If you don't have a mounting press, you can use a household iron to do your mounting. Use the same setting on the iron as suggested for tacking the mounting tissue to the print (see step 1). Cover the print with a double thickness of kraft paper, and run the iron back and forth over the print. Keep the iron moving, and work from

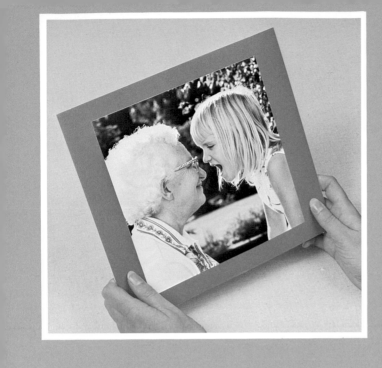

Underlays in gray, black, or color dress up a print.

the center of the print toward the edges. Don't push down too hard or you could mar the surface of the print.

Underlays in gray, black, or color dress up a print. Here's how to mount a print with an underlay:

1. Tack the dry-mounting tissue to the print, and trim off the excess tissue.

2. Tack the print to a piece of art paper that is slightly larger than the print. Do this just as you would to tack the print to a mounting board.

3. Tack dry-mounting tissue to the art paper, and trim the excess tissue.

4. Tack the art paper to the mounting board.

5. Mount the print with a mounting press or a household iron.

Another way to mount prints is to use overlay mounts. You can buy overlay mounts in art- or photo-supply stores. There's no actual mounting involved when you use an overlay. Just lift the overlay and slide the print into place. Then tape or glue the bottom corners of the print to the mounting board. While these mounts are fine for temporary or home use, they usually aren't acceptable for photographic contests or salons.

You may also mount your prints by using a photographically inert cement, such as KODAK Rapid Mounting Cement. This cement is packaged in small tubes and is especially suitable for mounting small prints in albums. Never use rubber cement for mounting paper-base prints because it may contain compounds which could stain your prints.

45

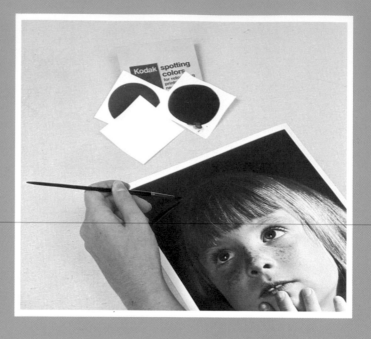

Apply the spotting color with a dotting or stippling motion until it matches the tone of the surrounding area—and the spot is no longer visible.

SPOTTING

Despite all the precautions you take against dust and dirt, most prints seem to end up with at least a few white spots. You can fill in the spots by using a good-quality spotting brush with an especially fine point. For spotting black-and-white prints, you can use KODAK Spotting Colors, which are dry dyes supplied in a set of three colors: black, white, and sepia. Another popular type of spotting dye for black-and-white prints is a liquid called Spotone.

To spot your print, dampen the spotting brush slightly and pick up a little spotting dye on the tip of your brush (you can mix colors if necessary). Rotate the brush to make a fine point. Apply the dye with a dotting or stippling motion until the dye matches the tone of the surrounding area—and the spot is no longer visible. It's best to begin with dark areas, and work on lighter areas as the dye works out of the brush. If the dye bubbles when you apply it, the brush is too wet.

TITLING

Printing the title of your photograph and your name just below the print adds the finishing touch. Keep the title short and simple. Ideally, the first letter of the title should start even with the left edge of the print. Print your name in the lower right corner in letters to match the title. The last letter of your name should be flush with the right edge of the print.

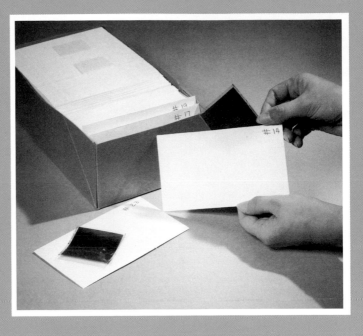

Your negatives will stay clean and unharmed when you file them properly.

SOME HELPFUL HINTS

Don't run off without filing your negatives safely for future use. For relocating a particular subject, it's a good idea to place an identifying number on the back of each print and on the negative envelope.

Also, the cleaning chore will be much easier if you do it right away. Be sure to wash all the containers and trays you used, and rinse the thermometer. Discard the developer you used, even if you think you could squeeze through a few more prints. Developers don't keep well—even overnight—in open trays and in a partially exhausted condition.

Are there any hypo marks on the splashboard behind your sink or on the floor? Fixer-spotted darkrooms not only look messy, but the fixer may become airborne. If fixer dust settles on photographic paper or film emulsion surfaces, it will cause small spots, called pinholes, on the emulsion.

The towels you used should be washed before your next printing session. This will help eliminate another possible source of mysterious spots on your negatives and prints. As you leave, check to be sure that all of the electric lights, including the safelight and the enlarger lamp, are turned off.

DARKROOMS—TEMPORARY AND PERMANENT

DARKROOM PLANNING

How elaborate you make your darkroom will depend primarily on your needs, finances, and space. To develop an occasional roll of black-and-white film, almost any makeshift arrangement will do. If you want to make prints and enlargements, you may want a well-equipped room that is conveniently arranged and properly heated, lighted, and ventilated.

The room must be lighttight. To check for stray light, stay in the darkroom for 5 minutes with all the lights turned off. After 5 minutes, if you still can't see a sheet of white paper placed against a dark background, the room passes inspection. If there are light leaks, you will be able to see them because your eyes will have become adapted to the dark. Eliminate small light leaks with black tape. For large ones, such as the crack around a door, use dark heavy cloth or weather stripping.

For your health and comfort, you should introduce a plentiful supply of clean, fresh air into your darkroom —especially during the chemical-mixing and processing operations. Be sure to follow the safety recommendations given in the instructions packaged with the processing chemicals. Check the photo magazines in your local library for articles on building lighttight darkroom ventilators.

Arrange your safelights so that they provide as much light as possible, but keep them at a safe distance—at least 4 feet—from your working area. Use a safelight equipped with a 15-watt bulb and the filter recommended on the paper (or film) instruction sheet. You can make a simple safelight test as follows:

1. Set your enlarging easel to give ½-inch white borders for the paper size you'll use in the test.

2. Place a normal-contrast negative typical of your work in the enlarger. Be sure the clear borders of the negative are completely masked.

3. Size and focus the image on the easel.

4. With all safelights on, make a good-quality print on grade 2 paper —or the paper you normally use. Develop for the recommended time in one of the developers recommended for the paper. Mark this print No. 1.

5. Turn the safelights off, and make print No. 2 in the same way as print No. 1.

6. Turn the safelights off, and expose print No. 3 in the same way as print No. 2. *Do not develop* print No. 3.

7. With the safelights still off, place a piece of cardboard over the developing tray and put print No. 3 on it, emulsion side up. Safelight illumination is generally brightest in this location. Cover one-fourth of the print with an opaque card and turn on all the safelights. In the same way that you would make an exposure test strip, expose print No. 3 to the safelight for 1, 2, and 4 minutes, in steps. This gives four steps with safelight exposures of 0, 1, 3, and 7 minutes superimposed on the image exposure. Develop this print for the same length of time as prints No. 1 and 2, with safelights turned off.

8. Fix, wash, and dry all the prints in the normal manner.

9. Compare the prints. Prints No. 1 and 2 should be identical. If print No. 1 shows lower contrast or fogged highlights when compared with No. 2, you have a serious safelight problem. Be, sure that the safelight filters (especially the one over the developing tray), bulb wattage, and distance and number of safelights are consistent with the recommendations on the paper instruction sheet.

If all three prints are identical, your safelight conditions are good. If print No. 3 shows slight fogging of highlights in any of the safelight-exposure areas, it is a warning to limit the time of exposure to safelight illumination to a time that will produce no fogging.

Note that fogging from safelight illumination will show up in areas that have already received some exposure before it will show up in the white borders. For this reason, safelight fog may go unnoticed unless the safelights are tested correctly.

In planning a darkroom, the main objective is to arrange your equipment and materials for efficiency and convenience. One of the most important requirements is to provide for a flow of work that can be done in the least amount of time with minimum effort. Another consideration is cost. Here are some desirable features for darkroom design and some suggestions you should consider in setting up your darkroom.

CAUTION: Some photographic chemicals, particularly acid solutions, may cause corrosion. To minimize the chances of damage to your sink and drainage system, use cold water to thoroughly wash the sink and flush the drain after each use.

TEMPORARY AMATEUR DARKROOM

For developing black-and-white films and making prints, you can get started with only a minimum of equipment, plus an easily darkened kitchen, bathroom, closet, or any other room that has an electrical outlet. For night work, you can use practically any room as a darkroom; however, you should pull the shades or cover the windows with some dark material to exclude light from streetlamps, car headlights, or nearby lighted windows. A sink and a supply of water are desirable but do not have to be in the same room. The kitchen is probably the most convenient place to set up a temporary darkroom, since it is supplied with running water and electrical outlets, and the sink and counters provide adequate working space.

When space is not available for setting up a permanent darkroom and you must work in a room regularly used for other purposes, darkroom convenience sometimes has to be sacrificed. However, always try to arrange your equipment to allow a smooth, convenient flow of work from your enlarger through the developer and stop bath to fixing and washing. You should have a large tray filled with water for washing your prints. The KODAK Automatic Tray Siphon is a handy gadget for converting an ordinary tray into an efficient print-washer. You should also have a container of water to rinse the solutions from your hands. This helps prevent contamination of your developer with other solutions.

Use a clean towel to dry your hands *thoroughly* before handling film, negatives, and photographic paper. Group your equipment so that you can perform all operations with a minimum of steps, but allow sufficient working space. One suggested arrangement for a kitchen darkroom is shown in Figure 1.

It is helpful to have a table or other separate work area on which you can perform all the dry operations, such as printing and loading film tanks. This prevents water and solutions from splashing on equipment and dry materials. Set up all wet processing operations in or near the sink.

If there is no lamp socket over your processing area, use an extension cord to suspend the safelight over the processing trays. Keep the safelight at least 4 feet from your trays. A good safelight to use in this manner is the KODAK 2-Way Safelamp, available from photo dealers. This V-shaped safelight directs the light in two directions at once. You can screw it into the lamp socket of an extension cord or into a ceiling socket.

The best way to develop your film, especially in a temporary darkroom, is to use a film-developing tank, such as a KODACRAFT Roll-Film Tank. Since these tanks are lighttight, any light that might leak into your darkroom would affect the film only during the time you are loading it into your tank. This minimizes the danger of light fogging your film, a frequent source of trouble. Check for stray light in your darkroom by following the procedure described on page 49 under Darkroom Planning. After you have placed the cover on

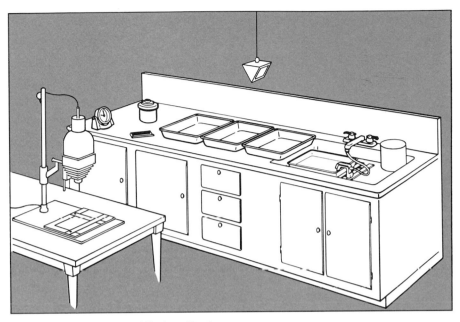

Figure 1 Temporary Kitchen Darkroom

your film tank, you can turn on the white lights during development and the remainder of the processing steps.

With a temporary darkroom, it is important to consider ways of reducing the time and energy required to prepare the room for use and to clean it up afterwards. For instance, keeping all of your darkroom equipment in one or two boxes reduces both the time spent collecting equipment and the chance of misplacing something.

While the kitchen usually makes the best temporary darkroom, other rooms will serve. One possibility is a bathroom. However, although it has running water and electricity, there is usually no work surface to support trays and apparatus. You can make a work surface by placing a piece of plywood on the bathtub,

but processing trays will be uncomfortably low. Sometimes it's possible to set up a card table to hold your trays and printing equipment. Protect the tabletop from spilled solutions by covering it with a piece of plastic such as a plastic tablecloth.

You can also use a small closet for a temporary darkroom. A closet is usually easy to make dark, even in the daytime. However, this is its only advantage, since it will have no running water and possibly no electrical outlets. Moreover, the closet probably will be filled with its normal contents. If your closet has shelves, perhaps one of them is located at a convenient height. If not, you may be able to install a removable shelf or bring in a small table. In any case, use plastic sheeting under the trays to catch any spilled solutions.

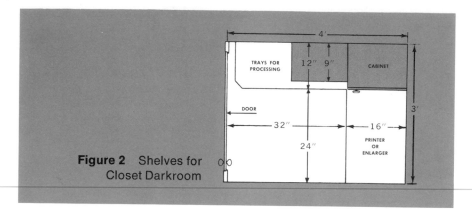

Figure 2 Shelves for
Closet Darkroom

PERMANENT AMATEUR DARKROOM IN A SMALL CLOSET

A permanent darkroom makes dark-room work much more convenient and saves a lot of setup time. If you have only a small closet available for use as a darkroom, make sure you utilize the space most efficiently.

A closet, of course, will not have running water, but this is not too important if there is a sink nearby where you can wash your negatives and prints. However, the closet must have electricity available. If there is no light socket in the closet, it is usually easy and inexpensive to have one or two outlets installed. It is desirable to have one socket in the ceiling for the white light and a double electrical outlet on the wall above the bench for plugging in your safelight and your enlarger or printer. Have a licensed electrician install or inspect the wiring to make sure that all wiring conforms to the electrical wiring code.

Figure 2 shows the arrangement of shelves for transforming a 3 x 4-foot closet into a darkroom suitable for developing film and making contact prints and enlargements up to 10 x 12 inches. The 12-inch shelf is 36 inches from the floor and holds the developing, stop-bath, and fixing trays. The 16-inch shelf is the same height and supports your printer or enlarger.

A cabinet in the corner (upper right corner of drawing) on the wall above the processing shelf provides convenient and safe storage for your paper supply. A shelf about 9 inches wide, 2 feet above the processing shelf, extends along the wall next to the cabinet and provides shelf space for a timer and other small items. This shelf should extend no farther than about 15 inches from the end of the processing shelf below so that it does not block the safelight illumination above your developing tray. Mount a safelight, such as a KODAK 2-Way Safelamp, on the wall or ceiling no closer than 4 feet from the processing shelf. You can store bottles of processing solutions on the floor under the tray shelf.

A RECOMMENDED AMATEUR DARKROOM

Although you can produce good work in a closet darkroom, it is preferable to have a larger darkroom equipped with running water. With more room, you can make bigger prints, and you'll have space for additional equipment. For example, in the darkroom we are going to describe, you can conveniently process color film and make color prints.

LOCATION

Where you decide to locate your darkroom will depend primarily on the space available. However, you should also consider convenience, temperature, and humidity.

Although a room on the first or second floor is suitable for a darkroom, a dry basement is usually the ideal location. If your basement is damp, you can make it dry by using a dehumidifier, available from appliance and department stores. The ideal relative humidity for darkroom work is betweeen 45 and 50 percent; the ideal temperature is between 70 and 75°F (18.5 and 21°C). It is usually easier to maintain this temperature in a basement than in any other part of the house. Furthermore, hot- and cold-water connections and electrical connections are generally available in a basement. Another advantage is the ease of making a basement lighttight. Most basements have only a few small windows that you can easily cover with a piece of fiberboard or dark cloth. One more advantage of the basement dark-

room is that spilled solutions are likely to cause little damage. However, all spilled solutions should be wiped up immediately.

A damp basement without a dehumidifier is not a good location for a permanent darkroom. Dampness causes mildew and rust on supplies and equipment. It also causes deterioration of films and papers, which results in weak, mottled pictures. However, if you must use a damp location, store your chemicals, films, and printing papers where it is cool and dry, and bring them to your darkroom only when you need them.

An attic is another location that is usually not satisfactory for use as a darkroom. Unless it is well insulated, an attic is likely to be too hot in the summer and too cold in the winter. Also, it is usually difficult and expensive to install plumbing in an attic.

SIZE

The layout for a recommended darkroom, shown in Figure 3, is designed to provide the utmost convenience in the flow of work. The space used for such a darkroom should preferably be neither smaller than 6 x 7 feet nor larger than 10 x 12 feet. The plan shown will fit within these limits.

You can close off the darkroom space from the rest of the area with partitions of wallboard. Although this is desirable, it may not be necessary in a small basement if your furnace burns oil or gas. However, if you have a hand-fired coal furnace, you should close off your darkroom to keep it free of dust from the coal and ashes. Also, par-

titions will prevent light from entering the darkroom if someone opens the door to the basement. As a precaution, put a sign that reads DARK —DO NOT ENTER on your darkroom door to show that the room is in use.

CAPABILITY

You can use the darkroom illustrated in Figure 3 for both black-and-white and color work. It is designed so that you can process roll film or sheet film; make proof sheets; and make enlargements up to 11 x 14 or 16 x 20 inches, depending on the size you make your darkroom. You can also readily adapt the room for other types of work, such as copying. The darkroom layout is arranged so that you can work efficiently with a minimum of wasted motion. It is also designed so that two or more people can divide the various operations and work together without interference. You can provide for drying negatives by stringing spring-type clothespins or film clips on a galvanized wire suspended between two walls in your darkroom. Use the clothespins or film clips to hold your films by the edges while they dry.

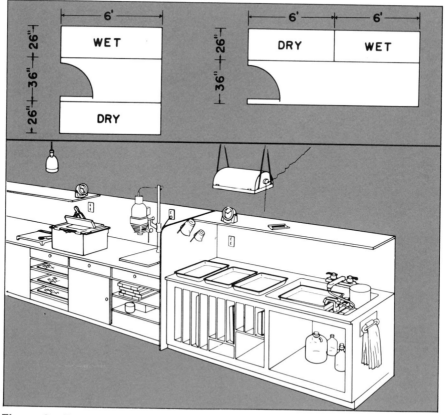

Figure 3 Recommended Permanent Darkroom

ARRANGEMENT

The darkroom units shown in Figure 3 consist of a dry bench and a wet unit, each 26 inches wide and 6 feet long. You can either have them built in a woodworking shop or assemble them yourself from ready-made kitchen cabinets.

Figure 4 Dark Drawer

Use the dry bench for enlarging and printing and for handling films, negatives, and photographic paper. Since storage space for supplies and accessories is very important for work in this area, drawers and shelves are provided. Also, it is convenient to have a lighttight drawer, or dark drawer, near your printing equipment. This will provide quick access to printing paper when you are making prints, and will eliminate the necessity of opening and closing the package of paper every time you need a sheet of printing paper. When you have finished printing, you should return the unused printing paper to its original package.

To make a dark drawer lighttight, install a sliding lid that fits in a groove around the top perimeter of the drawer. Paint the inside of the drawer and the lid flat black. Attach a small block of wood on the top of the lid and another one on the underside of the countertop. The blocks of wood will push the lid closed when you close the drawer.

You can use the space on top of the wet (or sink) unit for mixing chemicals and for all processing operations. Storage space for processing trays and chemical solutions is beneath this bench. Shelves mounted 2 feet above each unit provide storage space for bottles of stock solution, timers, thermometers, and other small equipment. Wooden pegs mounted on the splash guard provide a place to keep graduates. A towel holder mounted near the sink provides a towel for drying your hands.

You can locate the dry and wet units either on opposite sides of the darkroom with ample space between them or side by side with a splash guard separating them. With either arrangement, your equipment and materials will be protected against water and solutions splashed from the wet work area.

A safelight is suspended over each unit at a distance of no less than 4 feet from the working surface. To provide safelight illumination for the dry bench, you can use a safelight, such as a KODAK Darkroom Lamp or a KODAK 2-Way Safelamp, with the proper safelight filter. For the processing area, we recommend a larger safelight, such as the KODAK Utility Safelight Lamp, Model D. Double electrical outlets, properly grounded, are mounted over the units for plugging in your printer, enlarger, and other equipment.

A hot-and-cold mixing faucet is mounted over the sink. The nozzle should be at least 15 inches above the sink bottom, to provide space for filling gallon bottles.

Because water and solutions will be spilled on the wet unit, it should have a waterproof surface. An excellent material for this is sheet plastic, widely used for kitchen counters and tabletops. Sheet plastic has an extremely hard surface which is resistant to most stains and corrosion. It is available in a variety of attractive colors and is easy to keep clean. You can purchase this material in sheets and cement it to the top of the unit, or you can purchase it as a laminate on plywood, a form that's easier to install. You can also obtain a professional custom-made plastic counter top; most cities have firms which specialize in such products.

Another material which you can use on top of the unit is linoleum. You can extend the linoleum up the back wall to the shelf to protect the wall from splashes and eliminate the sharp, dust-catching corner at the rear. Treat the linoleum with a hard wax, rubbing the wax thoroughly into the surface to prevent penetration of spilled solutions. You can install vinyl floor materials in sheet form for the counter top of the unit in much the same manner as you would install linoleum. Vinyl is somewhat more expensive than linoleum, but it is more resistant to spilled solutions. Corrugated rubber matting also makes an excellent covering since it is resistant to chemical solutions and is easily cleaned. You can also use rubber sheeting. If you don't install a waterproof covering,

the joints in the bench top must be tight enough to prevent solutions from dripping onto the shelf below. Also, to protect the wood, coat the bench top with a chemical-resistant paint or lacquer.

PLACEMENT OF YOUR EQUIPMENT, FLOW OF WORK

If you study your work pattern in the darkroom, you can readily see the reasons for the recommended arrangement of the bench units and equipment. To make enlargements, for example, you take the package of photographic paper from the paper-storage shelf, open it, and place the paper into the dark drawer. After placing your negative into the enlarger and composing the image on the enlarging easel, you place a sheet of printing paper into the easel and expose it. (For proof sheets, you can place your printer or printing frame onto the bench next to the enlarger.) After the paper is exposed, you pass it on to the developer and the rest of the processing solutions. Then you wash your prints in the sink or in a tray equipped with a KODAK Automatic Tray Siphon.

When you have completed your work, you can place all equipment—including the printer, easel, and trimming board—on a shelf below the bench. This leaves the bench top clear for other activities.

One last point to remember: Darkroom cleanliness is very important for making pictures of high quality. Rinse the processing equipment you have used with water, and wipe the work surfaces clean with a damp viscose sponge.

SPECIAL THINGS TO DO

MAKING A PHOTOGRAM

Once you've mastered the fairly simple arts of processing your film and of making prints or enlargements, you have all the equipment and skills you need for putting your hobby to work in a number of useful and fun ways.

A photogram is an illustration made on a sheet of photographic paper without using a negative. It consists of white or gray designs on a black background. The high-contrast appearance of a photogram is dramatic, and clever photograms are

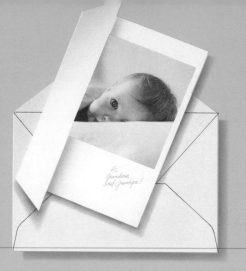

Greeting cards are fun to make and are uniquely personal. They let your creative urge run wild.

GREETING CARDS

easy to make. All you need are a few small props and some photographic paper.

Under suitable safelight conditions, arrange some opaque or semiopaque objects on a sheet of photographic paper with the emulsion side of the paper facing up. Leaves, shells, paper cutouts and letters, and even your hand or a pair of scissors are just a few good props for making photograms. When the arrangement suits you, turn on the exposing light. Use the light from your enlarger or a 7-watt light bulb. You'll probably need to experiment a bit with exposure time, depending on your light source. Process the paper in the usual way, and you'll have an original photographic creation!

Maybe you've noticed that you seem to receive more and more photo Christmas cards each year. There's a good reason for the trend. Such cards are fun to make and are uniquely personal. They let your creative urge run wild.

There are lots of ways to make such cards. You can take a picture with a built-in greeting, such as someone writing on a blackboard. You can combine one of your negatives with another negative containing a suitable message. Or you might prefer slipping a print into a commercially made Christmas folder. Your photo dealer will help you with ideas and materials. And although we've been talking about Christmas cards, there's no reason why you shouldn't make your own photographic birth announcements or other special-events cards. Ask your photo dealer for KODAK Publication No. AC-18, *Ideas for Photo Greeting Cards.*

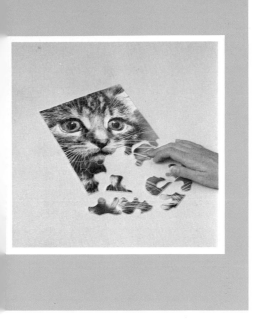

PHOTO JIGSAW PUZZLE

Making a photo jigsaw puzzle is simple and a lot of fun. All that's needed are a mounted print (with a border of at least 1 inch), a pattern, photographic mounting cement, a straightedge, and a utility knife and blades.

To make a pattern, begin with a piece of paper the same size as the mount your print is on. Make an outline the size of your print. Draw the pieces along the border first, slowly working toward the middle until the pattern is complete. Remember that the pieces must interlock to form the puzzle effect.

Next cement the pattern to the borders of your print. Be sure to align it carefully. With the utility knife, start cutting in the middle of the picture, leaving the cuts around the border till last. To protect your working surface, place an extra piece of mounting board or other suitable material under the print.

When all the cutting between the pieces has been done, trim the borders. To avoid a light border on the finished puzzle, use a straightedge as a guide to trim the puzzle slightly smaller than the original print. Your puzzle is now complete!

It's a good idea to store your puzzle in a box. If you're giving it as a gift, why not make a copy of the original print and paste it onto the box as identification?

PHOTO ESSAYS

This isn't strictly darkroom advice—but it's so important we think it's worth a word. One of the important things some people do with pictures is to make reports, whether they're for work, or a club project, or a school requirement. When you step into the darkroom to make such pictures, here are some things to keep in mind. First the pictures should show very little except what's necessary to make the point. Crop your prints to show only the things that are important. Use captions to direct attention to what isn't obvious. Make the prints match in size and be relatively uniform in tone. If you're making prints to mount into an album, 3½-inch-square prints are about as small as you should make. If the prints are to be on a bulletin board or easel, 8 x 8 inches is the smallest size usually appropriate. In most display areas, lighter prints are easier to see than darker prints. Good picture sequences are planned ahead of time, not made in the darkroom.

OTHER PAPERS AND CHEMICALS

CHOOSING AN ENLARGING PAPER

Kodak offers a large variety of black-and-white photographic papers, each with different characteristics, from which you can select the paper that will produce the best possible prints from your negatives.

The characteristics of photographic papers are divided into two general classes—photographic and physical. The photographic characteristics of a paper describe its contrast grade and its speed. The physical characteristics describe its coating, image tone, surface sheen and texture, stock tint, and weight.

PHOTOGRAPHIC CHARACTERISTICS

Contrast Grade

Kodak makes papers of several contrast grades so that you can make good prints from negatives of different contrasts. Some negatives have low contrast—little difference in blackness (density) between their light and dark areas. Other negatives have normal contrast. Still others have high contrast. To produce normal contrast in your prints, use low-contrast paper with high-contrast negatives, and high-contrast paper with low-contrast negatives. Use contrast grade:

No. 1 for negatives with high contrast.

No. 2 for negatives with normal contrast.

No. 3 for negatives with somewhat less contrast than normal.

No. 4 for negatives with low contrast.

Some Kodak papers are available in five or six contrast grades, ranging from No. 0 for printing very high contrast negatives to No. 5 for printing very low contrast negatives. Other papers are supplied in only one contrast grade for use with normal-contrast negatives. Papers such as KODAK POLYCONTRAST Papers have selective contrast; you can change the contrast of the paper by using special filters. The contrast grades of KODABROME II RC Paper are soft, medium, hard, extra hard, and ultrahard.

Speed

Paper speed indicates the paper sensitivity to light and is much less than that of most films. The speeds of several Kodak papers are given in the data book *KODAK B/W Photographic Papers* (G-1), available from photo dealers. Enlarging papers are higher in speed than contact papers, but you can use most Kodak enlarging papers for contact printing as well when you reduce illumination in your contact printer. If the intensity of the light source in your enlarger is typical of the intensity of most enlarger light sources, a moderately fast enlarging paper, such as KODAK EKTALURE Paper, will have adequate speed for most printmaking. Contact papers require a high-intensity light source, and most enlarging lamps lack the illumination required for using contact papers.

PHYSICAL CHARACTERISTICS

Resin Coating

Resin coating, a characteristic of all KODAK RC Papers, is growing in popularity. Resin-coated papers have a water-resistant base to help prevent penetration by processing chemicals. This reduces the time needed for fixing, washing, and drying the paper. It also eliminates the need for ferrotyping. Use an F-surface RC paper if you want glossy prints. This surface has a built-in gloss.

Image Tone

Image tone is the color of the photographic image in the finished print. When the image of the print tends

toward brown, it's called warm in tone; when the image tends toward blue, it's called cold in tone. Image-tone designations for Kodak papers are blue-black, neutral-black, warm-black, and brown-black. When you plan to use a chemical toner, select a paper with an image tone that is compatible with the toner. See the instructions that come with the paper or toner. For information on toning see KODAK Publication No. G-23, *The ABC's of Toning,* available from photo dealers.

Surface Sheen

Surface sheen determines the maximum blackness (density) the paper is capable of producing. The glossier the surface, the blacker the maximum density and the greater the possible range of tones in the print. Kodak papers come in the following sheens:

Glossy paper is a good choice when you want the most brilliant prints and the best reproduction of fine detail, such as for album prints and for pictures to be published in books and magazines. To obtain the highest gloss, you should dry glossy prints on ferrotype plates or on a ferrotype dryer. The exceptions to this are prints made on *all* KODAK RC Papers. Do *not* ferrotype these prints.

High Lustre paper has a sheen slightly less than that of glossy paper. It's especially suitable for producing prints that require a great deal of brilliance without ferrotyping.

Lustre paper offers a sheen midway between Glossy and Matte. It gives an intermediate brilliance to portraits and other subjects requiring moderate sparkle.

Matte paper subdues brilliance and is frequently the choice for low-key (dark-tone) or high-key (light-tone) pictures and atmospheric landscapes.

Texture

Texture or surface roughness largely determines how the paper reproduces fine detail—the smoother the surface, the finer the detail. Kodak papers come in the following surface textures:

Smooth paper has no noticeable surface pattern to interfere with reproduction of fine detail. This is the best surface for small prints.

Fine-Grained paper has a slightly pebbled surface which adds richness to a print without loss of definition. It's excellent for exhibition prints, scenic views, and portraits of young people.

Silk paper has a clothlike texture with a high-lustre surface. It's effective for still lifes, snow and water scenes, wedding pictures, and some portraits.

Tweed paper has a rough, pronounced texture which tends to subdue fine detail, emphasizing masses in landscapes and portraits. It's suitable for large artistic prints.

Tapestry paper offers an unusual texture that somewhat resembles an artist's canvas. It subdues detail to a maximum extent, being most effective for making large prints.

Stock Tint

Stock tint is the color of your paper stock. Your choice of tint will depend on your subject and the kind of paper you want to use. Kodak papers are furnished in the following tints:

White is recommended for cold-toned subjects—snow scenes, seascapes—and for high-key pictures and prints you want to tone blue. It's also good for general use.

Warm White is excellent for general subjects when you want a degree of warmth in your prints. This tint is midway between White and Cream White.

Cream White is also an excellent choice for general subjects. It's well-suited to subjects photographed by either daylight or artificial light.

Weight

Weight describes the thickness of the paper stock. Kodak papers come in Light Weight (LW), Single Weight (SW), Double Weight (DW), and Medium Weight (MW). Double-weight and medium-weight papers are preferable for enlargements because of better handling characteristics.

REFERENCE TABLE

The reference table on page 64 lists the physical characteristics of Kodak black-and-white photographic papers and the contrast grades available for each kind of paper. For example, say you want to use an enlarging paper that has a neutral-black image tone and a smooth, glossy surface. Find the names of enlarging papers with a neutral-black image tone—take KODABROMIDE Paper for instance. Then look for the letter designation in heavy type under the headings Smooth, and Glossy—the letter **F** in this example. The information given with **F** surface tells you that the paper stock is white (WH) and the paper is available in both single weight (SW) and double weight (DW), in contrast grades 1 through 5. When there are no contrast-grade numbers given for a paper, this indicates that the paper comes in normal contrast only or that it is a variable-contrast paper. See the following descriptions of the papers.

KODAK BLACK-AND-WHITE PHOTOGRAPHIC PAPERS

KODAK Papers	Texture ▶ Surface Sheen ▶ Image Tone ▶	Smooth Glossy	Smooth Lustre	Smooth High Lustre	Smooth Matte	Fine-Grained Lustre	Fine-Grained High Lustre	Silk High Lustre	Tweed Lustre	Tapestry Lustre
Contact Papers										
VELOX	Blue-black	F-WH SW 1-4								
AZO	Neutral-black	F-WH SW 1-5 DW 2				E-WH SW 2,3 DW 2,3				
Enlarging Papers										
MEDALIST	Warm-black	F-WH SW 1-4 DW 2,3				G-CR DW 2,3				
KODABROMIDE	Neutral-black	F-WH SW 1-5 DW 1-5	A-WH LW 2,3			E-WH SW 2-4 DW 2-4				
KODABROME II RC	Warm-black	F-WH MW S-UH*	N-WH MW S-UH*							
POLYCONTRAST	Warm-black	F-WH SW,DW	N-WH SW,DW A-WH LW	J-WH SW,DW		G-CR DW				
POLYCONTRAST Rapid	Warm-black	F-WH SW,DW	N-WH SW			G-CR DW		Y-CR DW		
POLYCONTRAST Rapid II RC	Warm-black	F-WH MW	N-WH MW							
EKTALURE	Brown-black					G-CR DW	K-WM-WH DW	Y-WM-WH DW	R-CR DW	X-CR DW
PANALURE	Warm-black	F-WH SW								
PANALURE II RC	Warm-black	F-WH MW								
PANALURE Portrait	Brown-black					E-WH DW				
Portrait Proof	Brown-black								R-CR SW	

KEY

Numbers indicate contrast grades.
Letters in heavy type designate particular combinations of texture, surface sheen, and stock tint.

Stock Tints
WH-White
WM-WH-Warm White
CR-Cream

Weights
LW-Light Weight
SW-Single Weight
DW-Double Weight

*Contrast grades soft to ultrahard (S-UH): soft, medium, hard, extra hard, ultrahard.

KODAK PAPERS

Contact Papers[6]

KODAK VELOX Paper is an excellent contact-printing paper for general use, such as for snapshots you want to put in an album.

KODAK AZO Paper is also an excellent choice for making contact prints from negatives of general subjects.

Enlarging Papers

KODAK MEDALIST Paper is a fine-quality, general-purpose enlarging paper. Its high speed is essentially the same for all its contrast grades. This paper features wide exposure latitude and a range of developing times that makes it possible to obtain *in-between contrasts* for producing the very best print from every negative. By selecting the contrast grade that best matches your negative and by varying the printing time and development time, you can get the range of tones (density scale) that produces the best print. Depending on your choices of developer and toner, you can obtain image colors ranging from warm browns, brown-blacks, and warm blacks to deep, cool blacks and delicate blue-grays. MEDALIST Paper tones beautifully in toners such as KODAK POLY-TONER and in KODAK Sepia and Brown Toners.

KODABROMIDE Paper is a fast general-purpose enlarging paper. It has high speed and exceptional development latitude; *contrast and image tone remain uniform over a wide range of exposure and development times.* This makes KODABROMIDE Paper a good choice for fast production of prints from a wide variety of negatives.

KODABROME II RC Paper is a medium-weight high-speed enlarging paper with a warm-black tone on a water-resistant base for general use. The F surface requires no ferrotyping. It is available in contrast grades soft through ultrahard.

KODAK POLYCONTRAST and POLYCONTRAST Rapid Papers are selective-contrast enlarging papers for general use. You can produce any of several contrast grades from the same package of paper when you expose your print through the proper filter, such as those supplied in the KODAK POLYCONTRAST Filter Kit (Model A). By using the filters in this kit, you can vary the contrast of the papers in seven half-grade steps from No. 1 through No. 4 contrast grades. No filter is required with normal-contrast negatives and tungsten-light enlargers. Selective dodging is possible when you expose one part of your print through one filter and the rest through another filter to achieve the desired contrast throughout. Two POLYCONTRAST Papers give you a choice of two speeds. With normal-contrast negatives, the speed of POLYCONTRAST Paper is similar to that of MEDALIST Paper, while POLYCONTRAST Rapid Paper is comparable to KODABROMIDE Paper.

[6]Because of their slow speed, contact papers should not be used with an enlarger. Use a printing frame and a 7-watt lightbulb. See page 22, step 7.

KODAK POLYCONTRAST Rapid II RC Paper is a high-speed selective-contrast enlarging paper of warm-black tone on a medium-weight, resin-coated base. Optical brighteners provide great visual impact through whiter whites and therefore a longer apparent tonal range. A water-resistant base shortens fixing, washing, and drying times and eliminates the need for ferrotyping with the F-surface papers.

KODAK EKTALURE Paper is excellent for exhibit prints and portraits. It's a fast enlarging paper that has a warm, brown-black image tone. The speed of EKTALURE Paper makes it a good choice for fast production of high-quality prints. This paper tones easily in such toners as KODAK POLY-TONER and KODAK Rapid Selenium Toner.

KODAK PANALURE and PANALURE Portrait Papers are designed for making black-and-white prints from color negatives. These papers are sensitive to all colors of light; as a result, the tones of the subject are reproduced in the print in their correct tonal relationship. One of the most outstanding characteristics of PANALURE Papers is that you can control gray-tone rendering of colors in the original scene in much the same way as you do when you use filters over your camera lens for taking pictures on panchromatic black-and-white film. By using the proper camera filter over your enlarger lens when you expose the print, you can darken a blue sky, for example. PANALURE Paper has a fast speed similar to that of KODABROMIDE Paper, and PANALURE Portrait Paper has a moderately fast speed similar to that of KODAK EKTALURE Paper. You can obtain pleasing brown tones on PANALURE Papers with several Kodak toners.

KODAK PANALURE II RC Paper is a high-speed enlarging paper designed for making prints from color negatives. Approximately twice the speed of KODAK PANALURE Paper, PANALURE II RC Paper contains an optical brightening agent which adds brilliance to the prints. The water-resistant, resin-coated base of this paper allows rapid processing and drying, and eliminates the need for ferrotyping.

OTHER CHEMICALS

With modern single-powder chemicals or with chemicals that you need only dilute to use, you can prepare enough chemicals for an evening of black-and-white processing and printing in about 15 minutes.

Kodak prepared chemicals come in units of different sizes in order to fill the needs of both the occasional printer and the printer who spends several evenings a week in the darkroom. If you do a lot of processing and printing, you'll probably want to buy the more economical, larger-sized units.

DEVELOPERS FOR FILM

KODAK MICRODOL-X Developer—Offers maximum enlargeability. Packed as a powder.

KODAK HC-110 Developer—A highly active developer supplied in liquid-concentrate form for handy use. It produces negatives similar to those developed in Developer D-76, but with shorter development times.

DEVELOPERS FOR PAPER

KODAK VERSATOL Developer—This is a general-purpose developer packaged in a convenient concentrated liquid form.

KODAK EKTONOL Developer—This developer is the primary recommendation for warm-tone papers. It is designed for minimizing processing variations and is good for prints that are to be toned.

KODAK SELECTOL Developer—This developer is intended for use with warm-tone papers.

KODAK EKTAFLO Developer, Type 1—This is a concentrated liquid developer. It yields neutral or cold tones on cold-tone papers. It is also a primary recommendation for some papers of warm-black tone.

KODAK EKTAFLO Developer, Type 2—This is a concentrated liquid developer for use with warm-tone papers. Its characteristics are similar to those of KODAK EKTONOL Developer.

STOP BATH

KODAK Indicator Stop Bath—This stop bath is supplied in a concentrated liquid form and makes up quickly and easily into a nonhardening stop bath for all papers. The solution is light yellow when mixed, appearing colorless under a safelight. It becomes purple when exhausted, appearing dark under a safelight.

FIXING BATH

KODAK Fixer—This is a hardening-fixing bath for all-purpose use with films, plates, and papers.

KODAFIX Solution—This is a general-purpose concentrated liquid hardening-fixing bath. It has long life and high capacity.

PROCESSING AIDS

KODAK Hypo Clearing Agent—Promotes faster and more complete print-washing.

KODAK PHOTO-FLO Solution—Decreases water surface tension; minimizes watermarks and drying streaks on films and speeds drying.

MORE INFORMATION

If you have additional questions about basic darkroom techniques, write to Eastman Kodak Company, Photo Information, Department 841B, 343 State Street, Rochester, New York 14650.

KODAK PHOTO BOOKS AND GUIDES

The KODAK Photo Books and the guides on the next page will provide you with many inspirational ideas for new and different techniques and present a wealth of reference material to help you in your darkroom. Ask your photo dealer for these books. If your dealer cannot supply them, order by title and code number directly from Eastman Kodak Company, Department 454, Rochester, New York 14650. Please send remittance with your order, including $1.00 for handling plus your state and local sales taxes.

BOOKS

KODAK Films—Color and Black-and-White

(AF-1) $3.95

Covers both color and black-and-white Kodak films. The text portion tells how to choose the right film and how to use it properly for best results. A data-sheet section gives all the details for each film, such as speed, exposure recommendations, and processing requirements.

Creative Darkroom Techniques

(AG-18) $7.95

An advanced book covering a wide range of darkroom techniques from methods of contrast control to photo-screen printing. This book shows many ways to make exciting new photographs from existing negatives and slides. It contains almost 400 illustrations in color and black-and-white.

Bigger and Better Enlarging

(AG-19) $10.95

A brightly illustrated, how-to-do-it book on enlarging color and black-and-white photos. Teaches you how to choose the right paper, determine exposure, dodge and burn-in, and finish your prints. Filled with clever darkroom ideas.

GUIDES

KODAK Darkroom DATAGUIDE

(R-20) $8.95

Gives you all the advice and data you should ever need in a black-and-white darkroom.

KODAK Master Photoguide

(AR-21) $5.75

Pocket-sized reference book on exposure, filters, lenses, and other essentials in dial-computer, table, and text form.

The lines of the mast and sails lead to the subject of this picture. These are called leading lines.

KODEWORD™ DARKROOM AUDIO CASSETTES

These new cassettes provide detailed audio instructions for processing several types of photographic materials including negatives, slides, and prints—both color and black-and-white.

All you have to do is select the KODEWORD Audio Cassette you want, have the right materials on hand (the back cover tells you what you need), set up your cassette player, and follow each step as detailed by the tape. With this new skill, you can become a more accomplished photographer—whether you're a professional or a hobbyist.

KODEWORD Darkroom Audio Cassettes are available only through your photo dealer. Ask for KODAK Publication No. TC-1 (CAT No. 131 6363), *How to Process Black-and-White Film and Prints Using KODAK Chemicals,* $6.85. If your dealer cannot supply this, order directly from Eastman Kodak Company at the address listed on page 68.

Prices shown are suggested prices only and are subject to change without notice. Actual selling prices are determined by the dealer.

By eliminating distracting backgrounds, you can create pictures with a lot of impact such as those above and to the right.